Dear Duane
Happy Holidays
To you & your family
[signature]
12/2000

Finding Your Way

THE STUDIO BOOK

Lois Main Templeton

Lois Main Templeton

Published in the United States
by Guild Press of Indiana, Inc.,
Indianapolis.

ISBN 1-57860-082-0
Printed in China

TO KEN

my

husband

and

my

friend

Book designed by Lloyd Brooks
Thrive³, Inc., Indianapolis

11

The Studio

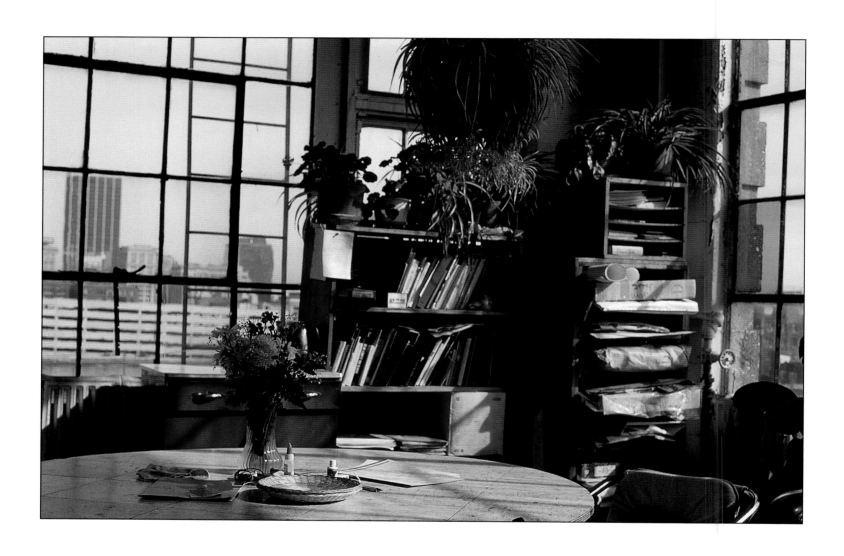

The Studio Book

CONTENTS

"EACH OF US LIVES A LIFE BEYOND TELLING," Lois Templeton tells us. "A studio is a place for finding one's own voice, an identity uniquely one's own." *The Studio Book* is about that life, that world beyond words, that life beyond telling.

Before I sat down to find my own words about this book, I spent a morning with Lois; not the person, but the essence – Lois as she has emerged over the years, as a painter, a creator, a human being living with all the joys and sorrows inevitable to each of our experiences no matter where we live, what path we must discover ourselves. I read *The Studio Book* from beginning to end; and from between its pages, underneath the lines, straddling the layers of painted images and text, Lois emerges; and along with her, an invitation. An invitation to those distant inner lands, lands that can only be visited by entering the passageways of each of our own unique experiences, ways of being, ways of seeing.

The Studio, Lois shows us, is a metaphor for the unique psychological and physical trajectory our lives take when we stop and listen to what the world, and our soul, is telling us. *The Studio Book* is about paying attention; to what's outside, what's within, and how they intersect.

Wassily Kandinsky, one of the first painters to create purely abstract pictures, believed in the necessity of allowing the farthest reaches of one's inner self to inform creative expression. Representational imagery may also inform the artist's choice of visual elements, but ultimately, abstraction is about that something that can't be defined. As Kandinsky wrote in 1931, "Today a point sometimes says more in a painting than a human figure...Man has developed a new faculty which permits him to go beneath the skin of nature and touch its essence, its content...The painter needs discreet, silent, almost insignificant objects."

Lois finds that nature, brings it forth, and gives it expression. Working with primarily abstract imagery, Lois gives a voice to that vast universe within each of us. Psychologist Carl Jung labeled that inner universe our subconscious; that largely silent aspect of ourselves that struggles to find an audience, to inform us, and those around us, with a more expansive view.

"Go back to caves. To objects/animals/inner feeling," Lois writes. "That's what imagination is all about: to understand what the eye can't see and the brain hasn't thought." Whether one is a painter or a composer – or none of the above – there's a richness to how each of us creates life and experience that deserves to be nurtured; and that, ultimately, is the space to which Lois's thoughts, images and observations draw us.

Inside Lois's studio, ultimately, we will find richness; and ultimately, if we listen carefully enough, we will find ourselves. "Is a studio necessary?" she asks. "Absolutely. This book is a tribute to having a space of one's own."

Welcome to Lois's space; and within it, may you find your own.

JULIE PRATT MCQUISTON
June 6, 2000
Indianapolis, Indiana

WHEN THE PHOTOGRAPHER JACOB KATZ WAS IN GUATEMALA, two little girls of the village adopted him. Every afternoon, as he returned from a shoot, they ran to him, their eyes dark with excitement: What had he done? Where had he gone? What had he seen? The children were deaf. Since he could not speak to them, he opened his pockets. They burrowed inside, exclaiming over his findings, his day's treasures and mysteries.

Each of us lives a life beyond telling, full of its own treasures and mysteries. The studio journals are my pockets. Paintings and poetry rework one's life experiences. They are to be read not as explanations but, like Jacob's pockets, as simple revelations.

*

When visiting an artist's studio, we hope to see both the work and a little of what lies behind that work. I think with my fingers. Since my studio journals are working notebooks, many pages make rather dull reading. Occasionally, however, observations crop up which hold one's interest. I have culled some of those entries, included appropriate paintings, and added new passages to help the reader pick his way through the experience revealed in these pages.

Finding Your Way: The Studio Book traces the journey of one artist. Rather than having a strictly chronological format, it is arranged to carry the reader through the repeated stages familiar to creative people. As the dates above each journal entry indicate, central themes reoccur through the years.

A studio is a place for finding one's own voice, an identity uniquely one's own. However differently each of us may express his or her identity as an artist, the need to be honest to one's own nature is common. That questions raised in the studio are equally alive for all of us in our personal lives should come as no surprise.

3/8/92

"Painting is like truth in that once in a while I see it immediately and clearly. More often it hides behind [the present stage] and only gradually reveals itself. The work of revealing a truth can only be done by the sweat of the person, one who is willing to destroy a state which is pleasing and which pleases in order to get to a deeper level. Acceptance of the need to go deeper only comes gradually."

—*Lois*

AN EXUBERANT

Entrance

Lois Main Templeton

What I want to have happen when people look at my work, is what happens

in jazz when, after all the diverse voices going on in improv, the group comes

together — and makes that turn. As the guy next to me said, "It's when the surfer

exceeds the wave just a bit — and plays with it without losing contact."

[3.21.83 notes from a jazz club in Cotati, California]

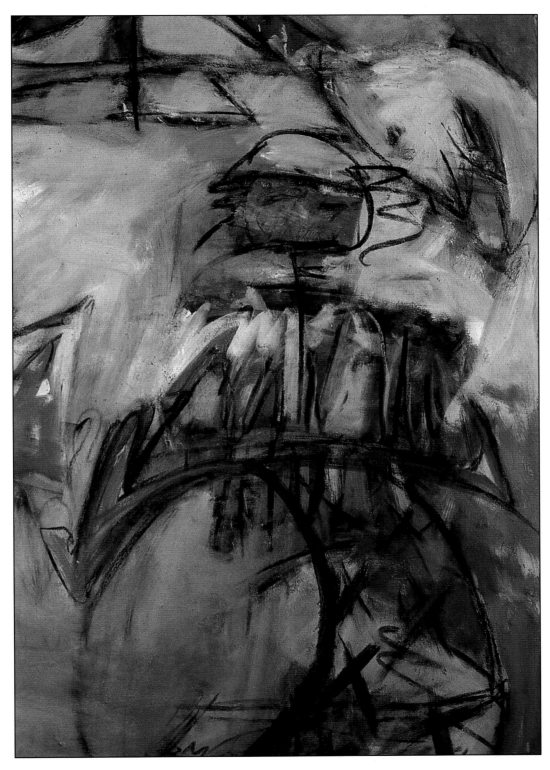

**The Open Road, (detail),
1990**
Oil and charcoal on canvas
72" x 82-1/2"

THE STUDIO

1982

Make it your own…a tree house, the prow of a ship.
Turn up the music, stretch out your arms, careen around the room.
Turn the tape low and become a small, insignificant presence
in a huge, white, empty, silent box.

Rip canvas into great sails — 8 feet by 10 feet and stretching…
and throw one on the floor. Scramble over its expanse with charcoal,
sloshing paint, brandishing brooms. Go ahead, slide across it.
Hang it up, dripping, accosting you–an independent person,
bigger than you. SAIL HO!

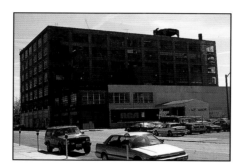

Faris Building
Circa 1984

4

Soledad, no. 3 of series, 1984
Acrylic and charcoal on canvas
95" x 111"

Lois Main Templeton

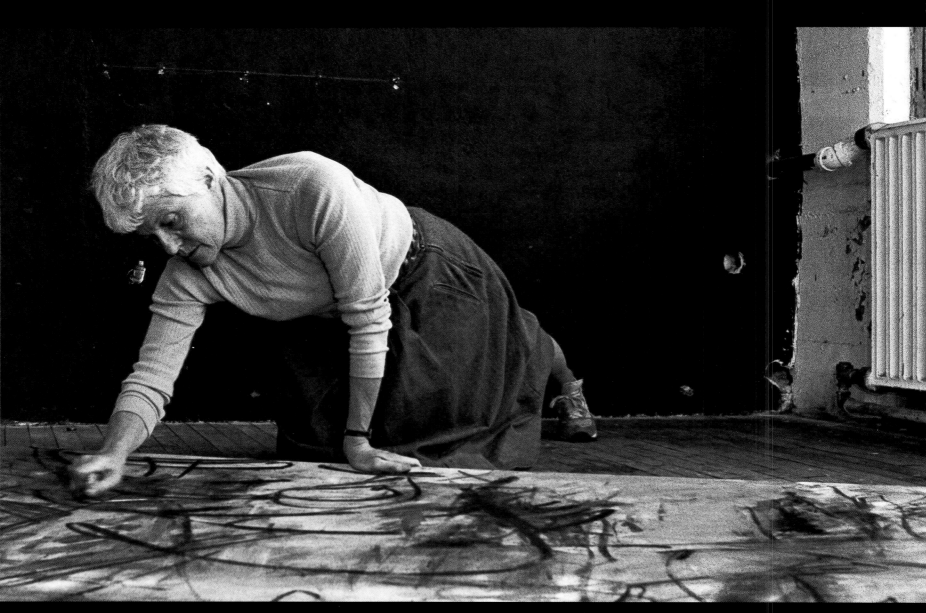

Arts Indiana,
May 1993

5/3/90

We wait for you.
No special stuff. Not arty,
just a coffee can – Folgers?
A big ol' brush. A few colors
to do – what – on that
immensity of white

WHILE ONE IS PAINTING AND DRAWING, an ongoing relationship develops between the artist and the work. During this give-and-take, these two disparate elements must come to terms. Gradually the painting becomes independent. The work helps the artist see farther; the artist adds cohesiveness to the work.

I generally start by asking the painting to tell me its own life history (which it knows very well, better than I). Doing so gives the painting its own standing. We then talk about what's going on at the moment. I, the artist (who am in control, you understand), use the experienced right hand. The painting, which may well know its own mind but is inarticulate, is given — (I hear, "TAKES!") — the left hand, whose awkward, loping, childlike scrawl requires much patience, resulting in an honesty often unsettling to the artist. Here the voice of the artist is indicated by the use of small letters, while that of the painting is in capital letters.

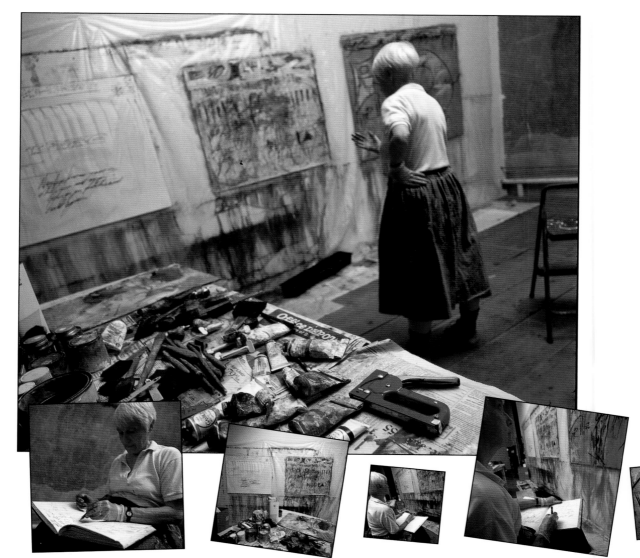

David Kadlec
Photographer
May 25, 2000

[Conversation with a painting, the artist leads off.]

5/7/93

Hi! Boy, you have a lot of tangled energy!
LET'S DANCE!
Okay. But you'd never get the "grand right and left."
Indeed, I see no partnerships.
YOU ARE LOOKING FOR DANCE PATTERNS.
True. Well. Where now?
KEEP GOING. GO WITH IT.
Err. Umm. Which order to it, etc.
JEEZ WOMAN! WHAT HAVE YOU GOT TO LOSE?!

THE CONVERSATION TAKING PLACE BETWEEN THE ARTIST AND THE WORK echoes the internal conversation so familiar to any creative effort. For the artist, it is a matter of gradually befriending oneself. As is true when talking with a painting, for the sake of this conversation I use both hands. The intuitive voice takes the left hand. The rational mind has the right. The left hand starts off…

7/14/90

ME FIRST! MY SPACE, MY YEAR…

I got it for you, though.

AWAY, PORTLY LADY! WHO DID "BLUES" AND "FROGGIE"?

Yeah, you're right.

THREE CHEERS FOR ME!

Suppose we act like a marriage — stereotypical — I shield and protect and handle your busi-

DON'T BE SO DAMN PATRONIZING!

Okay, okay. But you have to give me a role in this year if you're to keep me out of your way in the studio.

I'LL WELCOME YOU HERE IF YOU LET ME MOVE FREELY.

5/30/93

All those big white canvases scare my "kid," who slides down hills, skates, loves materials to push around. Actually, it isn't she who is reluctant. It's the Planner, the Saver, the Critic who sees NOTHING THERE to decide about, not even to go with, and who certainly doesn't want to waste all that well-planned preparation time (and $) by turning it over to this nice, but inadequate, kid — whom she's constantly having to rescue and make sense out of (mostly too soon!).

5/30/93

The Scot [in me] said, "Pastels are not IMPORTANT ENOUGH for my carefully prepared big sheet of paper." (In spite of Joan Mitchell!) Got 'em out anyway. But the same Critic says, "You'd not do a good job with oil bars." (Amazing, in view of what I have done!) Critic says, "That was a Past Accomplishment, and you were lucky. This morning you are inept." This is a repeated message. I seem to be stuck with it, but call out in defiance, "Anything worth doing is worth doing badly!" Once in a while an inner knowledge of some great strength (calligraphy?… distortion?) comes in and rudely shoves aside that judgmental voice.

11/19/84

This huge studio is the cat's meow. Am working on large canvasses, scrambling across them on the floor, enjoying the process of drawing and painting with the freedom permitted when you no longer fear falling off the edge. I like their immediacy and spontaneity. They will hang unstretched, keeping their sense of scale, of breathing room. We need that in our lives.

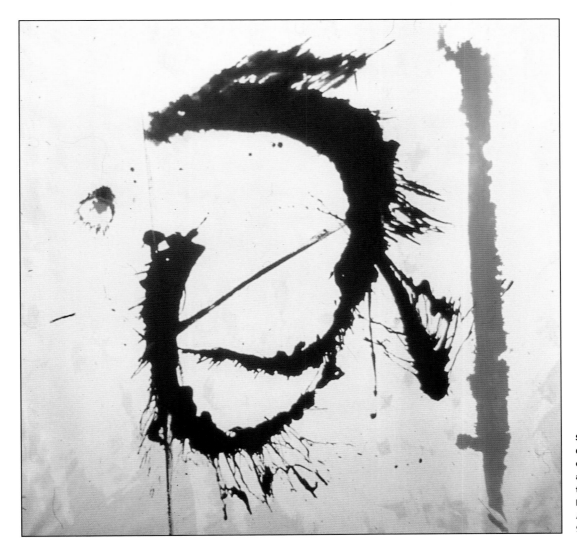

Saturday I took my dragon for a walk on his pogo stick, and he had a little trouble getting the hang of it, 1981
Acrylic on canvas
92" x 88"

Winter, 1983

Painting is like baseball. You play with the geometry of space — a field, a diamond, a foul line. With the arc of a ball and with the bat — a wielded line.

It involves scrambling. I'm at my best when I whack and scramble.

It is this action that interests me more than pictorial or narrative or conceptual bases. I like the interplay of action/discipline, organic/inorganic, passion/restraint.

Words come in as comments on the action: gestural remarks from the bleachers or, perhaps, like a voice lost in the shuffle. I want a canvas to play like a completed event in a baseball game, all seen at once (a double play, let's say). One's eye travels the canvas as if it were the action on the field.

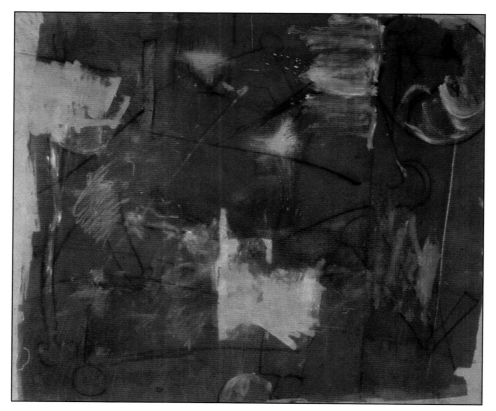

Got Rowdy, 1982
Oil and charcoal on canvas
74" x 87"

Opposite:
Pen and ink studies, 1991
Mixed media and collage
on paper
9" x 12"

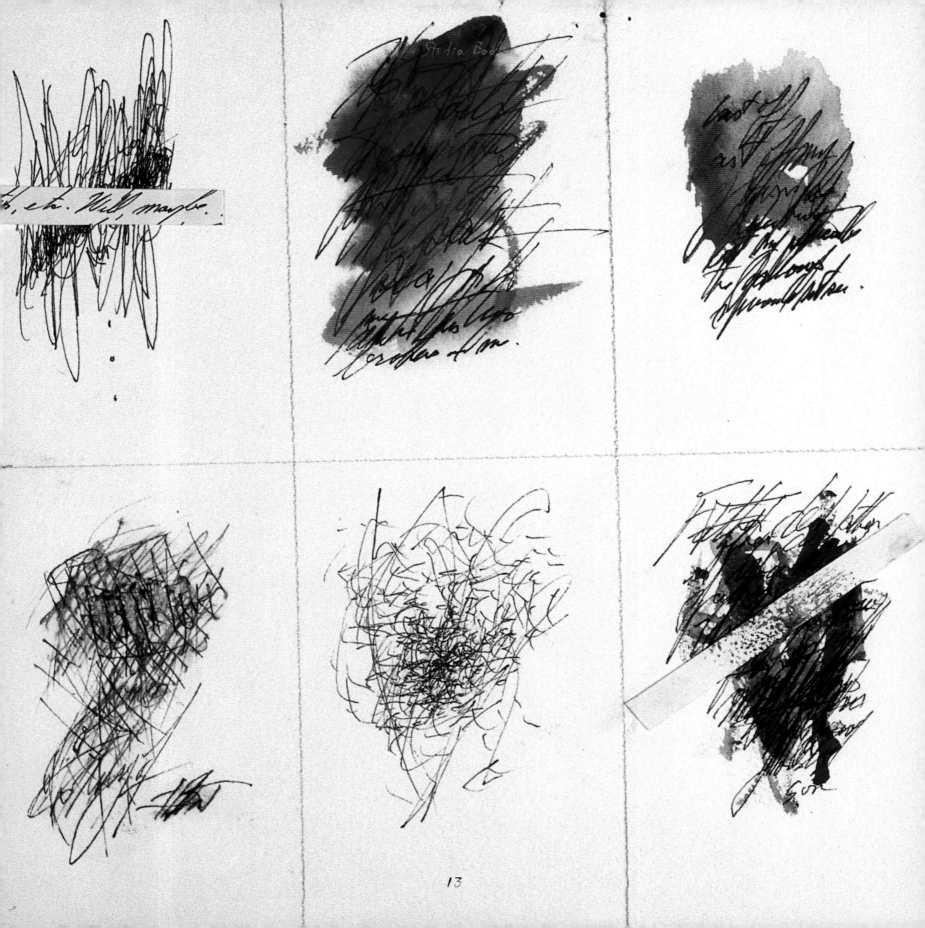

SURFING

The Studio

*

LEAVING MY EASEL, I walk to the window. The afternoon fog bank piles high above the Coastal Range south of San Francisco. Soon it will spill down over the redwood-covered slopes, roll on over the Fine Arts Building, over the foothills, and on down across the Bay. We shall awake tomorrow to a world shrouded in a cool, white mist. I turn back to the easel in the painting studio where I claim a few square feet as my turf and can work away, oblivious to all but the few chatty types. My kids offer to make a sign for the back of my shirt. It is to read, "BUG OFF."

*

THE TIME IS 3:30 on a Friday afternoon in Indianapolis—the tag end of a six-hour life drawing class at Herron School of Art. My newsprint is covered with ground charcoal dust. A rip appears where the eraser bit through. The instructor appears by my side, and I put a hand on his sleeve. "Don't worry about me. This is just how I work. I keep searching for what feels right." "Never take anything less," he says and moves on. The sheet of newsprint is still empty at four.

*

SQUARE FOOTAGE does not make a studio. Concentration does. A studio is any space dedicated solely to the absolute focus essential to making art. I left art school at age fifty-one with every intention of becoming as good a painter as was in me to be. And that meant a studio. That the Faris Building had space and that Bob Faris took a chance on me, was my great good luck.

A studio is any space dedicated solely to the absolute focus essential to making art.

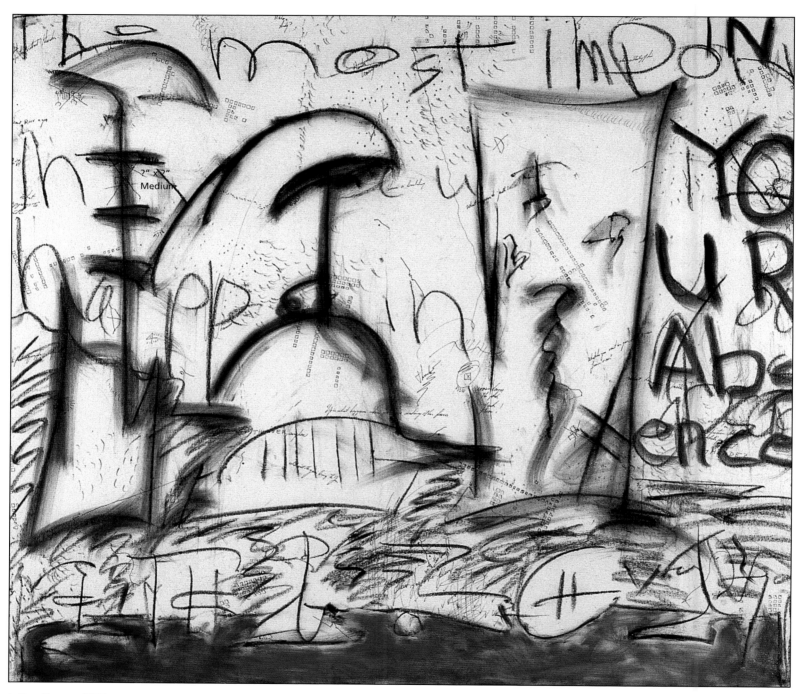

In Your Absence, 1985
Oil and mixed media on canvas
38" x 44"

Paradise Point on the California coast is a great place to surf. I watch one wet-suited figure wade out, plop his board into the water, wade some more, scull with his aching arms way out beyond the breakers where other dark figures sit, bobbing, waiting for The Big One. When the water rises, he senses it, is ready, gets to his feet, and rides that gorgeous curler for what seems forever — 'til it lets him down far off along the beach. A tiny speck, he picks up his board and begins the long trudge back.

In the studio, that surfer comes to my mind. When a painting is in full swing, life is glorious. Ride the wave as long as it will carry you. Nothing in the world outside matters. Most studio days, however, are spent pushing out past the breakers, or waiting patiently for a sea to rise, or trudging sandy miles back to where you started. As the journal dates indicate, this cycle returns repeatedly in our lives.

1/16/84

Looking up Meridian Street on a glittery, snowy night. Three years ago I had just the end of a string in my hand. All I knew for certain was that I would use charcoal and calligraphic gesture scribbled into the paint. That's not much to go on.

Now, three years later, I stand at the window of a gorgeous studio, I teach at the Herron School of Art (and am about to leave for class). I'm in Patrick King's gallery — and the curator, Lisa Lyons, is sufficiently interested in my work to scout a tentative appointment. Zounds!

Clearly, ambition had struck. Offers of six shows in two years, shows including both coasts as well as the Midwest, were too much to resist. Surely the fact that several galleries required work measuring inches rather than yards, surely that could be overlooked! With regret I left those great canvases swinging in the studio and began producing art in response to expectations…but even working on the floor could not recapture the glory. I slogged on, adding to an already complicated teaching load, taking on community concerns. My studio partner and I wrangled. My husband and I lost parents, our sisters, welcomed grandbabies, moved twice, and what have you — this happens. It all goes into the pot and, eventually, into one's work. At times, though, it is easy to give up.

4/21/86

Two months' absence from the studio. Launching the lecture program is a big, totally time-consuming, exciting job. I don't know whether making such a big deal of this lecture program will do me any good — or is even necessary. Couldn't PAINT today. Was all upper and cheerful 'til trying to paint. I directly went to slobber-slime-grime and zilch. I did not want to paint, and put it off as long as I could, and feel like crawling into a hole with pen and paper and possibly books and Saga cheese and bourbon. Go away and let me think. Why do I paint when I want to write? Anymore, ever. I don't know what I'm painting about. This makes me impatient and bogged down. Still I expect to make a painting instantly. What a drag!

11/21/85

A grey, darkening day. Keith Jarret brings me deep down into his mood. We are accompanied by rain spattering on the windows. Car headlights glare on shiny streets. (Where is the thunder?) I eye the woman in the compact mirror. When I think of myself, I see the hooded left eye. (It was even hard to get the mirror to reflect the right eye.) I can get nowhere. Even with great music, and while diddling thoughtfully on a contemplative day, even then, I have NO idea what to do visually. I live without joy. That's a sobering fact.

"Paint the void," he said.
"No, really, just don't paint
Something you see."
Easy to say.

3/31/99

I ran out of steam yesterday. Big time. Even with 3 more hours of daylight, just turned tail and fled. Good thing, too. Stopped at Shapiro's for take-out lox platter. O'Malia's for brie (tch, tch), Ginseng tea and $. Gas. So it was twilight as I pulled in the driveway. No energy left . . . each day has only so much — an adequate barrel-full. But I am down to the bottom of that barrel by end of the afternoon. Light supper, no cook, a beer — and then a long sleep. It's a working pace. I need to remember that construction workers keep at it (take breaks, but return to work) and pace themselves — unless the boss is a slave driver. I have the world's most insatiable driver inside. So the worker says, "Knock it off!"

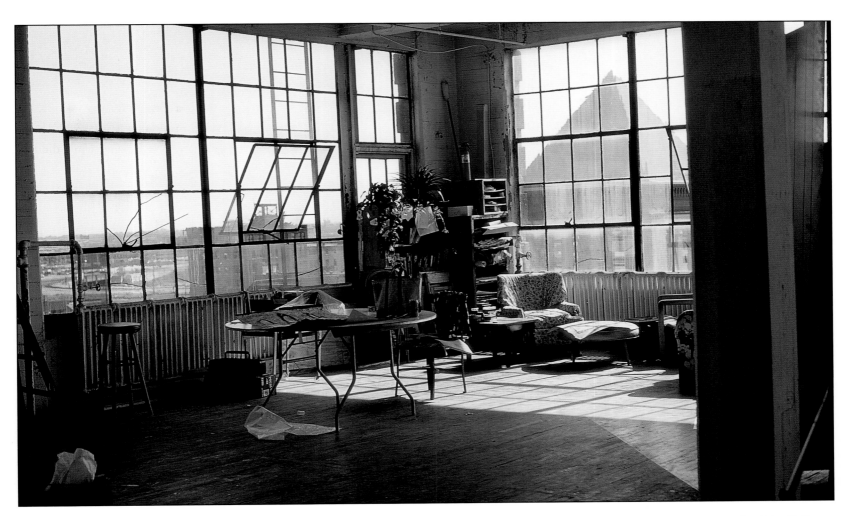

**Templeton Studio
in the Faris Building,**
Indianapolis

MAKING ART, WHETHER WITH MUSIC, WORDS, MOVEMENT, OR IMAGES, demands long periods of gestation. Indeed, most of what we call creativity is downtime. Even while we artists are doing something quite ordinary, we are paying attention to the real stuff going on underneath. Gestation is one thing to know about, quite another to experience. Desolation is what we feel. Like that surfer off Paradise Point, we pick up our board and begin the long, lonely trudge back to where we started.

2/24/92

Not an easy day. I just can't seem to get anywhere with any piece — indeed, lose what I have done and am in some middle, very contradictory stage. I can't seem to paint or draw. All works on paper are in trouble. Do I really want to live this way? Think I'll stop and go home. Take a walk with Ken and see where he thinks I am.

1/23/86

Go back to caves. To objects/animals/inner feeling. That's what imagination is all about: imagination understands what the eye can't see and the brain hasn't thought.

1994

I have trouble with the drawings on this page. All are very formal — the intellectual eye. That's not where my poetry comes from, let alone the painter's voice.

Keep thin, like skin,
So you can see below, down to thought, to inference,
Down where intuition lies.

*

3/22/96

I can't show these to anyone. They may not be any good. Roger says the planning committee wanted to take "FEAR" out of the agenda for the Symposium. You've got to be kidding!

5/30/95

I'm like a skier who stops after each turn and asks, "Was that all right? How'd I do?"

1985

It helps to use a tape of meditative music so that I go down and hand matters over to the unconscious without pestering it constantly with drilling operations to see what's going ON down there?!

1985

Squint. This almost eliminates the eyes, lowers brain waves to Alpha. Turning the paper throws off the left brain, too. Gets gravity out of the way for a few seconds.

Almost you came.
I lost the nerve
Like you, I stopped short
Of some Border.

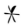

3/19/96

MORE snow! Hey! Made a snowman!

12/6/93

Saw Jessica Tandy and hubby in a film on TV last night. "Good people," he said. "Are *we* good people?" "No," she said. "We're more than that. We're interesting people." A nice painting is, well, nice. But I want more. I want an interesting painting. Since it's Advent, the thought occurs to me that if God's purpose had just been to make people *nice*, He hardly would have gone to all that bother.

11/27/92

I stand up and go to the north window and watch the trains, the traffic, a semi backing into that hospital equipment place, somehow still making it. The old brick, wholesale grocers' building. The room behind is big, sunny, empty, silent. I am quieted. This time given over to becoming gathered feels right.

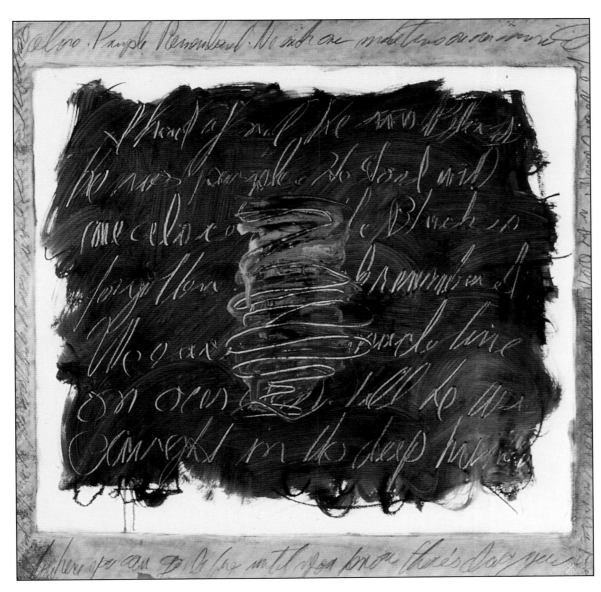

Purple Remembered*, 1992
Oil and mixed media on
paper
42" x 42"

8/5/93

Some pieces want to start with nothing to say. So you don't force them, you just keep them company. I guess you keep a painting company as you do a person. In the end you can say (as I could to a friend who saw his life as a series of failures), "But you became yourself, and that's more than most people do." When it has become itself, you don't judge it, you just let it be.

**music and lyrics by Jason Wesley Anderson*

ONFISHINGAND

Other Matters

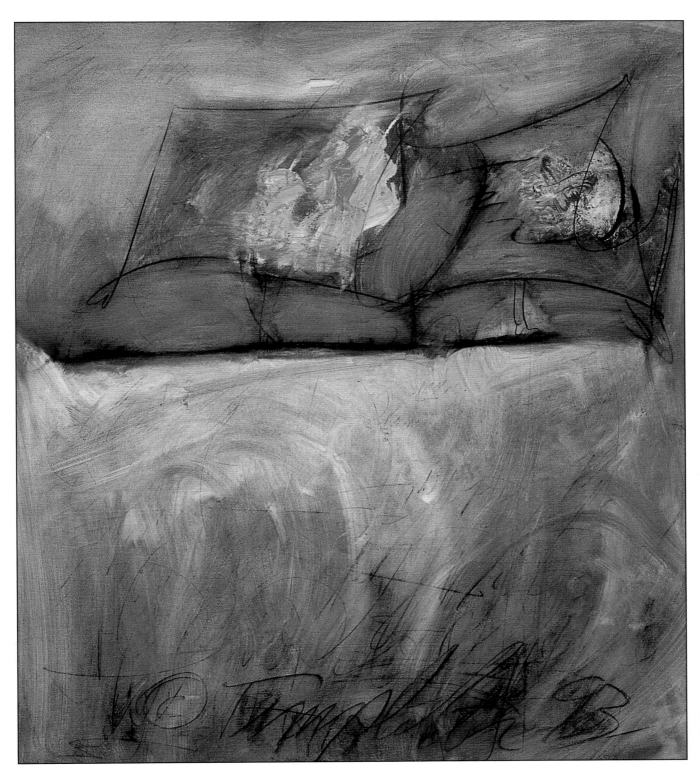

All Out of the West, 1994
Oil and mixed media on
paper
42" x 36"

1/27/86

If the thread is broken, the fish is off and away in the depths. In fact, art's a lot like fishing — gathering the gear, contending with the weather and the bugs, a lot of rowing, of trying various baits and weed beds, of losing "the one that got away" and, once in a muskie-moon, bringing home a keeper.

How can I know what I think 'til I see what I say?!, 1992
Oil and mixed media on paper
42" x 42"

FISHING, WHEN YOU'RE A MIDWESTERNER, calls for getting up in the dark, grabbing a cup of coffee, stumbling down to the row boat, bailing her if the night was rainy. Fishing means shoving off in the lake-fragrant dawn, slapping mosquitoes, rowing with creaky wooden oars, leaving a gentle wake. Fishing involves mist burning off the pickerel weed, some bait, a few strikes, losing some, landing enough for breakfast. And all the while you know "Old Mo" lurks in the depths, five feet of muskie, finning silently, snapping at foolish minnows, waiting only for your bait to bring him, thrashing, to the surface.

Now, I never got to go fishing. In the 1930s, I was only a girl, and a small one. But I remember how the men returned in the old Plymouth (held together by baling wire, my Father said). Their faces scratched as they picked you up — once for tease, twice for love. They smelled glorious. Forget the rips, the blisters, the sunburn, the mosquito bites, the empty creel. Their eyes shown. They'd been to Heaven and back. Painting is like that.

Catching, even engaging, a painting requires not bait, but immersion. That's true for all creative people. When we are interrupted, brought suddenly to the surface, we get the bends. We cannot stay down and still reply to a question. Oh, we hear the voice; we are not deaf. But we have the tail of a fish in our hands. If we let go, surface, and reply (or explode), we may be able to move down again, but that fish is off in the dim waters in which we grope once more.

In those silent waters, writing began to float like strands of seaweed.

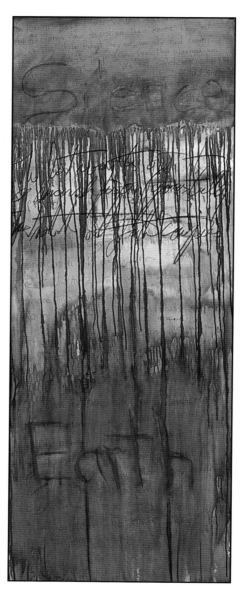

My father, John Main, was born in 1876.
Wisconsin was still The West, a land open
to a couple of boys on their farm horses.
Later, in the days of the Great Depression
(and after my Godfather, Vroman, had been
taken to California by his Evil Wife),
my father let me tag along when he went
birding in those fields and marshes. I was
the youngest and, besides, liked to keep
quiet and poke about. He died when I was
twelve, leaving behind a young poet, a
child herself in need of marshes, of open land.

Did You Hear?, 1996
Oil and mixed media
on paper
53" x 28"

The Kodo drummers, heaving and glistening in their own sweat,
Let their arms come to rest on their knees.
They sit.
We sit.
Silence.
They sit…we fidget.
They sit…we stir and cough.
They sit…we look for the program.
(Was this planned we want to know?)
They sit. We sit.
Silence envelops all. And we sit.
Far off, half-heard, far off and high — a flute note.
Silence.
Another — there!
In the quietness we strain to hear the calls
Of that first dawn.

The best way to get to a marsh is on your belly,
Wriggling under barbed wire. We come to the holy on
Hands and knees —

Just watch out for the cowpies.
The red-tail's keen slices the sky;
Off there in the pasture a killdeer cries.
Silence.
Wind stirs in the cattails.
A bass swirls.
Tree toads mate in sweet descant.
Shorebirds pick and scatter without alarm.
My father sees it all, knows his child is safe
Even as he once was on the good Wisconsin earth.

And so we returned him, that icy November day,
To the same earth.
We were brave and did not cry before the grave.
But the birds sang.
I suppose that means nothing to you,
But they sang that hour.
In the bare branches overhead they sang.
"Did you hear the birds, Dickie?" my mother asks.

12/91

Death now is like a backboard, a certain Power facing me. Like a backboard, it returns my shots.

Death is a horizon, part of my landscape, like a plateau. It doesn't feel like a gulf or a cliff that's scary, but as one you'd climb down to water and a deeper reality.

That's my death. Losing anyone dear to me is a whole other matter. I'd see their wonderfulness, their fragility, and realize that I'd not sufficiently cherished them and let them really know it.

Death is what makes our Present — graveyards are monuments to people's presentness.

Death draws a line — right there — adds up the sum of who you were, became, whom you blessed or failed, what you accomplished.

Death is a return to humus — the physical completion of our humanness.

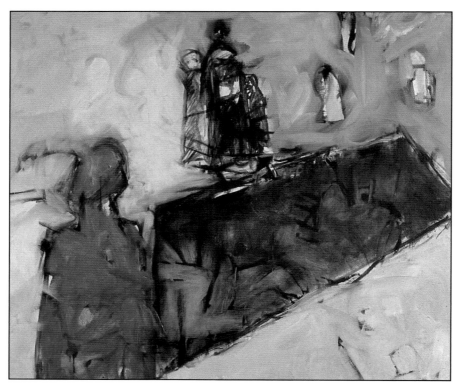

Tribute, 1989
Oil and
mixed media
on paper
60" x 60"

5/4/91

My first day since January to just do my thing in the studio — a soft, rainy day. Breakfast at Shapiro's with that nice, fat, blowsy lady. Then wrote Betsy. Studio all open and airy — feels great. Put washes on "Song for an Ebb Tide." Feels comfortable, but it's cracking. I will let it dry and then varnish the bejesus out of it with hope of stabilizing it. I really like this piece and this way of working now and then, so need to get the problem licked. As for "Ebb Tide," I will give it to John eventually, and if it doesn't last indefinitely, neither will I!

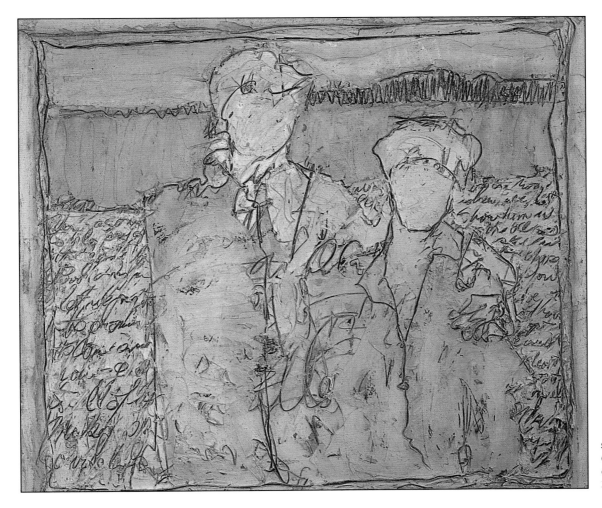

Song for an Ebb Tide, 1990
Oil and graphite
on canvas
36" x 40"

IT'S "HOWTHEYTOUCH

Each Other..."

"I THINK THE POINT WHERE LANGUAGE STARTS TO BREAK DOWN as a useful tool for communication is the same edge where poetry and art occur…If you deal only with what is known, you'll have redundancy; on the other hand, if you deal only with the unknown, you cannot communicate at all. There is always some combination of the two, and that is how they touch each other that makes communication interesting." — BRUCE NAUMAN*

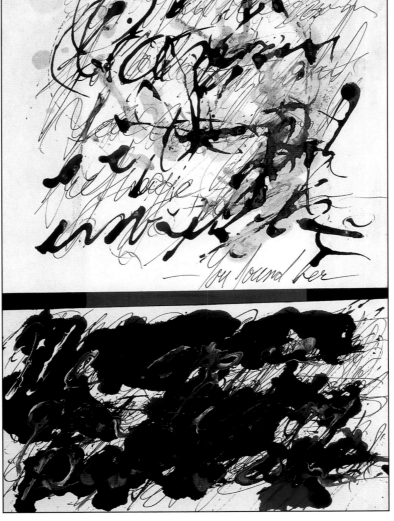

You Found Her, 1995
Mixed media collage on paper
13 3/4" x 9"

*Ludwig Wittgenstein, quoted in Robert Storr, "Beyond Words," in Neal Benezra and Kathy Halbreich, Bruce Nauman: *Exhibition Catalogue and Catalogue Raisonné,* ed. Joan Simon (Minneapolis: Walker Art Center in association with the Hirshhorn Museum and Sculpture Garden, Smithsonian Institution, 1994), 55.

Good Lord!, (detail), 1995
Oil and mixed media on canvas
42" x 48"

1983
People are too damn full of sweetness,
light, flowers, sparkle.

4/18/96

One month ago, I set off for the Center [Mary Anderson Center for the Arts in the Indiana hills lining the Ohio River]. Found I was taking the known road and, so, spent the rest of the day turning willy-nilly. Sandhill cranes. Spring peepers, that little ridge road…continued to let that happen for the next two weeks. Came home with a whole wall full of creative refuse consisting of sketches, doodles, splotches, a playful brush, disasters, really nice bits, experiments that worked — and those that didn't. It is functioning on its own and will eventually become the focus for a show. For a desultory, undirected exercise and "a waste of time," that's not half bad.

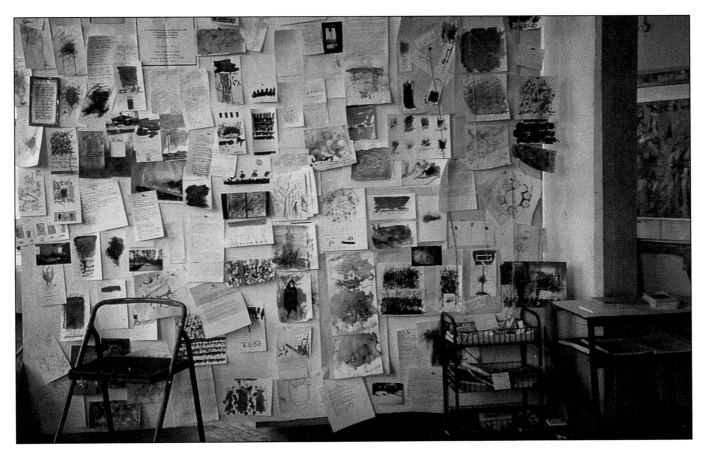

A working wall, 1996

IN THE BEAUTIFUL, HILLY COUNTRY of southern Indiana, known hereabouts as Floyd's Knobs, Franciscan monks and discerning art supporters have established a residency center for artists. A sensible, red-brick house stands above the hay meadow stretching down to a small pond, fishing boats overturned on the shore, wooded hills beyond. Heaven. Off to one side, beside the old barn, is the blue-doored studio. Winter, wrapped in snow, is best.

The test of a good retreat is not in goals reached or work accomplished, but in U-turns. When, day after day, sketches would not come, and I had run out of those books full of creative exercises, I did the next best thing. I threw a tantrum worthy of a four-year-old. Wuzzled up the papers, hurled them all over the room, clenched my fists, slammed down on a stool, grabbed a pen…and started writing. The words spilled out, uncorked. That U-turn opened onto the world of writing for its own sake and as a finally acknowledged aspect of my work.

Grasping the significance of this, Julia Moore, Curator of the Indianapolis Art Center, later suggested that we move the clearly experimental, on-going process so apparent in the wall as it developed at Mary Anderson Center, into a gallery at the Art Center where other artists and writers could participate. In 2000 the Richmond Art Museum used the wall in much the same way.

The full life of an art experience begins with the uncertainty and isolation essential to the artist's studio. If you are lucky, if someone has been watching your progress over a period of time, the work may then move on into the interaction possible as it develops a life of its own.

[FOR RICK]

It is written that he died of AIDS.

But did you know that he was an Indiana farm kid,

And that there were twenty-two in his graduating

Class; that his stretchers were square

And his brush marks small and measured,

Or that he was kind and observant

And steady,

And wanted to be sure of things.

Today the snow falls so gently

As it covers his body.

Rick Macy, a talented classmate and, later on, a studio partner, died at age twenty-three. In the days before his death, he asked me to come to his house and take all his painting materials back up to our studio. They were in my hands as I began the residency.

Lois Main Templeton

Notes from a Residency

I shall
look to the
right, I
shall look
to the left,
I shall
NOT stay
in the
middle of
the road!

Wonderful day. Woke early, made breakfast, tromped through snow drifts to the studio. BLISS. The tree outside my bedroom window was flocked white and outfitted with little winter birds — nuthatch, chickadee, junco.

✳

I shall look to the right, I shall look to the left, I shall NOT stay in the middle of the road! I have set myself up for getting lost; it is only then that I am deeply satisfied, that I am found.

✳

This is my world. This funny little kitchen (Who didn't do his dishes?!), a corner bedroom that's just perfect, the blue-doored studio at just the right distance. These are my world, and the snow protects them and me.

✳

When you think of it, handwriting is just an arbitrary, encoded action combining lines and curves into shapes.

✳

The snow falls in big, slow flakes; music fills the room. It feels so good. The faucet drips, the furnace rumbles and rattles companionably whenever it wakes up. I move to musing of my own.

We almost didn't go, you know —
But we went down the lane.
The cows itched their backs on my drying sheets —
But we went down the lane.
Dust kittens bred and rolled under the cribs —
But we went down the lane.

We crossed the creek and took the old stage road
Clear up to where that spring wets the ground;
Poked around up there. Shadbush was in bloom.
Came back to the wooden bridge for Pooh Sticks.

Lovesick heifers bellowed their lusty frustrations
From the far side of the stone wall.
You swung on grape vines, and we sang;
Came back full and contented.

"What did you do today?" he asks.
"We went down the lane."
"Is that all?"

You know how dreams are — it was our living room,
More or less. A few of the kids were hanging around
When Frannie came, sat on the arm of my chair.
No, the couch. I was sitting on the couch.
She told me everything she'd been doing,
And we had the best time. She was, of course, seventeen.

I woke happy, delighted with our visit,
Sat right down and wrote her parents,
"Last night Frannie stopped by, and we had
a wonderful long talk. I wish I could tell you
what she said, but I can't; only that she was radiant,
and so — Frannie."

They park the car along the road
And come down the path through the spruce
In the morning sunshine after the mail is in.
We talk, we watch the tide, we peer through binoculars
To see what the lobsterman is hauling in his trap.
Someone's children are wading in the tide pools.
There are always children for the tide pools.

They walk back up the path, and, turning, say,
"We came for Frannie."
I know.

Frannie Burnett was part of our summers on the Maine coast where her parents, have an old shingled cottage as we do. Her death at seventeen was grievous, but her vivid spirit is my life's companion.

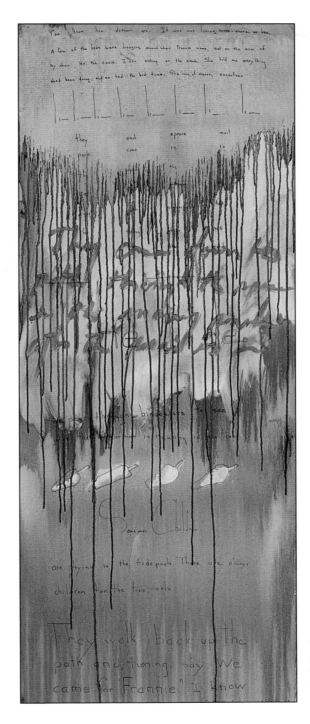

**You Know How Dreams Are
no. 1 of series, 1996**
Oil and mixed media on
paper
53" x 21"

[From an Interview at Eiteljorg Museum, May, 1998]

I GOT TO GO INTO MARSHES WITH MY FATHER, looking for the wild, looking for the edge. This lack of fear of being lost is very western. We do not need to have a map first. Certainly this has a bearing on my painting. When half-way through, I often don't know where I am, and certainly don't know where I'll end up. This is what it means to be completely caught up in the process. I want my lines to be electric, the paint to run, and the painting itself to become transparent — transparent visually and transparent personally.

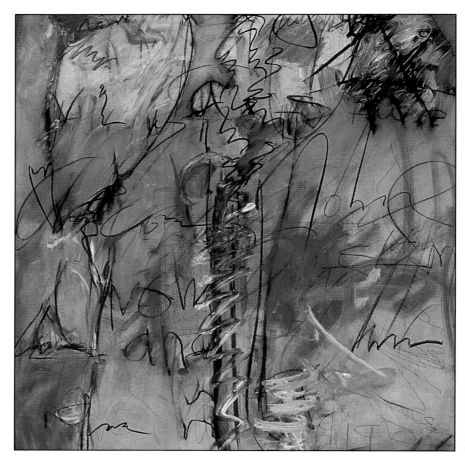

Of Course It Was Illegal no. 3 of series, (detail), 1996
Oil and mixed media on paper
42" x 36"

2/25/96

It's about skin. About seeing through. "I can see through you!" is either a threat — a real put-down — or a very great compliment: "Through you, I can see!" For an expressionist painter, this is a very live matter.

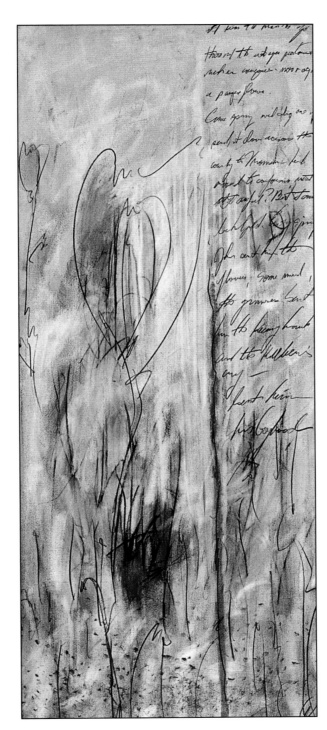

It was the marshes he loved —
Those and the wide open pastures
Rich in cowpies and, now and again,
a pasque flower.

In Spring we'd dig one up,
Send it clear across the country
To Vroman.
He'd moved to California;
Isn't that awful? But it can't be helped.

Once a year John sent him
The flower, the mud, some grasses
The keening hawk, and the killdeer's cry:
Sent him his boyhood.

**Of Course It Was Illegal
no. 4 of series, 1996**
Oil and mixed media on
paper
49" x 21"

He took the other side,

Said I'd find him where the marsh ended.

But you can bet I kept my eye on the far shore.

He wore corduroy pants that whispered as he walked,

And he smelled of pipe tobacco — sometimes Bay Rum.

I had my side; mosses and toads,

Cowpies, bones of mysterious origin,

Indian tobacco;

Overhead, an empty sky.

He took the other side,

Said I'd find him where the marshes end.

But I find only wind in the cattails.

Where does the marsh end?

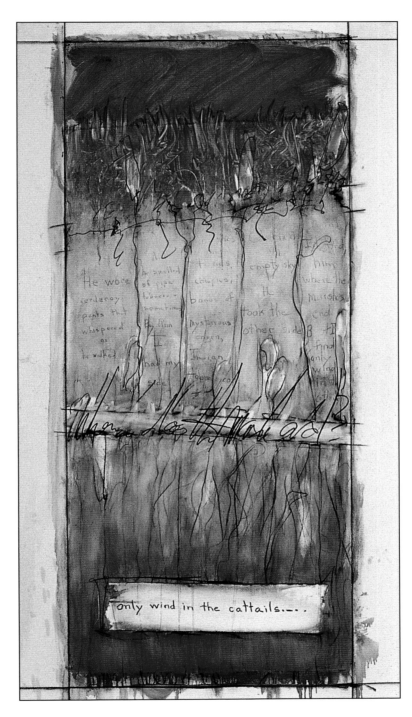

only wind in the cattails.__.

**Wind in the Cattails
no. 1 of series, 1996**
Oil and mixed media
on paper
58" x 30"

1/27/86

Writing, and a few symbols coming with it, now seems more directly in touch with the stream of consciousness. Since it is the unconscious that is my basic source, and the materials themselves simply the medium for its expression, an artist has to keep wrapped up in it — the way one "keeps silence."

Room for Thought, (detail),1994
Oil and graphite on paper
36" x 42"

TAKE**ME**WHERE**THEY**PLAY

The Blues

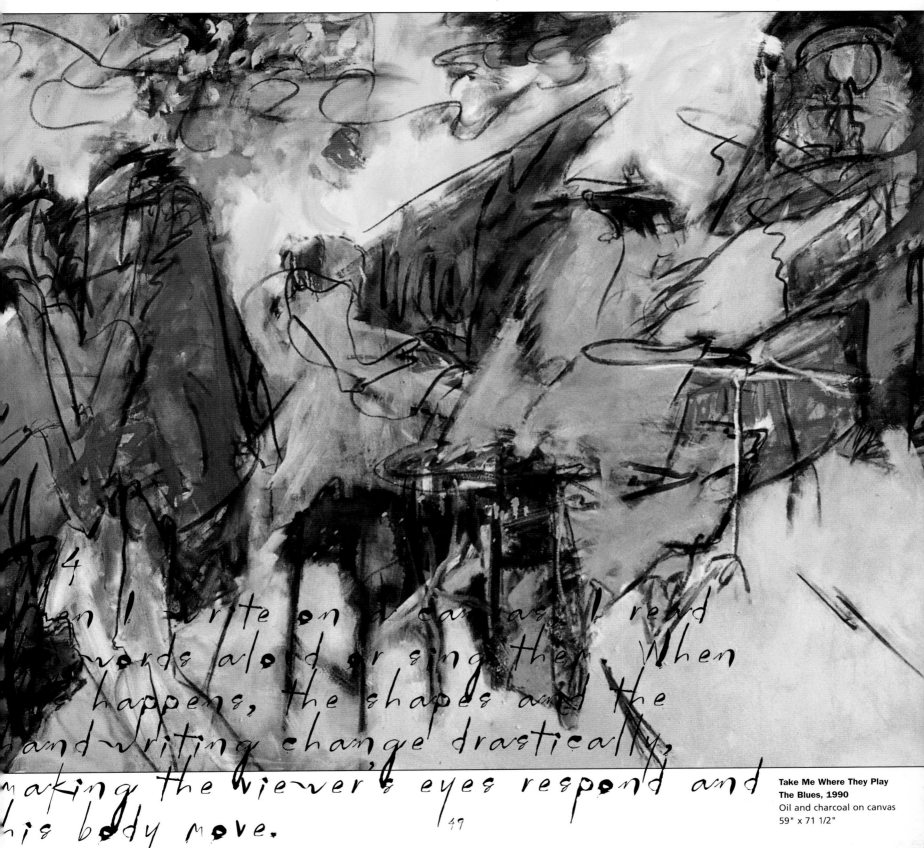

When I write on a canvas, I read
words aloud or sing them. When
this happens, the shapes and the
handwriting change drastically,
making the viewer's eyes respond and
his body move.

Take Me Where They Play
The Blues, 1990
Oil and charcoal on canvas
59" x 71 1/2"

[Interview at the Eiteljorg Museum of Western and Indian Art]

WE LIVED IN THE SAN FRANCISCO BAY AREA for two decades, and I had come back changed from the experience. Oh, yeah, we had gone hiking and river running; we had camped up in Desolation Valley — all that stuff — but what really changed me was my friends there who were Black…. We were good with each other and comfortable with each other. And I learned so much, was given so much, that I became a different person. No one did that more than a singer by the name of Donny Hathaway.

We went over to Oakland one time when Roberta Flack was there, and with her was this kid I'd heard about — Donny Hathaway. Our seats were close to the stage. Some stuff was going on, nothing much, a little music — and then a figure emerged, walking slowly across the darkened stage, picking her way through the instruments, singing… "The First Time Ever I Saw Your Face" — oh, my God. The whole place just went bonkers.

Accompanying and singing with her was Oakland's own Donny Hathaway. Our kids were almost his age, in college and high school, and his voice lived in our house. Then there was a time, a year or so, when we didn't hear from him. Word on the street was that he'd gotten into drugs; no one seemed able to help. And the headline came that he had died in a fall from one of the tall buildings in Oakland. The house fell silent. Our kids, especially, understood that sometimes a person can't hold it together. While this painting was developing, the composition came to reflect that time in Donny's life. The painting became much as he was, a deeply soulful person — who lost his hold.

All we have of Donny now is his music. He is with me in the studio. I was listening to his voice while painting, and it became a piece for him. Art does this, you know.

5/98

The music that saturated a certain time in our lives still plays inside us. Young Ken can hear what each musician is playing simultaneously. Wish I could. Jason's songs continue to play within us all. In those Bay Area days of the 1960s and 70s, our closest friends (some, anyway) were living beyond the pale. I take the long view these days on a life rich in others. Far from being maudlin, it puts a light on them. I may be the eyes and mind — and heart — that does the looking, but it's them wot does the living. These eyes/mind/heart often get snagged on, caught by, friends who live in the borderlands. Friends in and out of prison — and the cop across the street.

Beyond the Pale — title for a series? A woman may seek to provide a home for those who live in these borderlands. Does a man deal with those relationships differently in his art?

[Journal entry tied to "Donny" ("Soul")]

7/1/96

(1) Wrote lyrics sung by Roberta
Flack and Donny Hathaway
(2) Added my own thoughts.
These may not show, but they
dedicate the piece.
(3) Slathered on Gamblin Transparent
Reds (all) and Indian Yellow
(4) Toweled it down.
(5) Planned to collage black paper
(Arches cover) on a diagonal to
represent canceling Donny [his death].
Even cut and put on. Looked
strong but obvious.
(6) Put hypodermics along top.
(7) Used some grey sludge (essential!)
left from reworking the purple half
of diptych. Ugly and city — but so?
(8) Wanted formality. Thought of
white (slapped my hands!).
(9) Eye fell on Rick's Hansa Yellow
Light. Remembered the virulent
messages of bitter yellows.
(10) Towelled on a lot of that right
over the grey sludge and left the
red ground.
(11) Wrote "DONNY" — it stitches the
parts together.
GOOD, STRONG JOB and conveys
the essential.

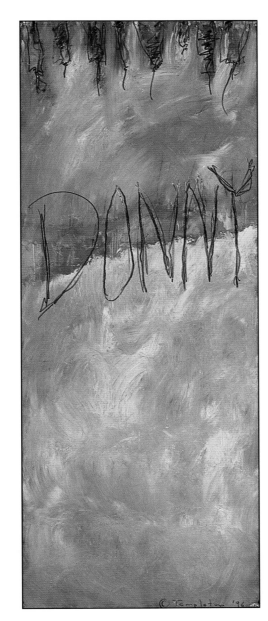

Soul, 1996
Oil and mixed media
on paper
53" x 21"

11/97

Music, lyrics, and poetry (mine and others') underlie my life, so they are "in the air" whenever I draw and paint. Rather than providing illustrations for those sources, my work searches out the common layer that underlies both our words and our images. Marks of a pen, graphite or charcoal mingle with transparent oils to offer a layered dialogue between thought and feeling, a record of call and response.

Jazz studies, 1994-1997
Oil, mixed media on paper

1994

When I write on a canvas,
I read the words aloud or sing them.
When this happens, the shapes
and the handwriting change drastically,
making the viewer's eyes respond
and his body move,
even if he's not aware of this.

2/17/93

Hooray! Great seven-inch snow yesterday. Today, SUN!! Frank Glover [jazz composer and musician] and I carted up to his studio the huge jazz painting I've done for him. Found, when talking about it with him, that my visual terms are also musical — which you know in your head — but it's nice when it works on the hoof. Piece looks great there.

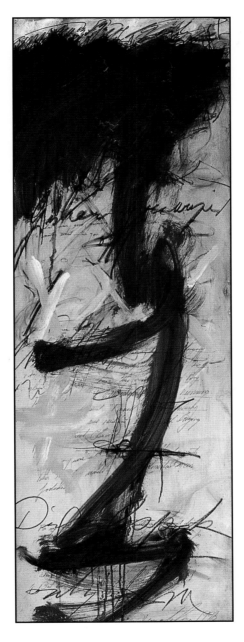

Young Tornado, Practicing, 1996
Oil and mixed media
on paper
54" x 19"

Photo of Red Rohall, Lois Templeton, and Frank
Glover in the studio, inventing the 1997 Indiana
Governor's Arts Awards

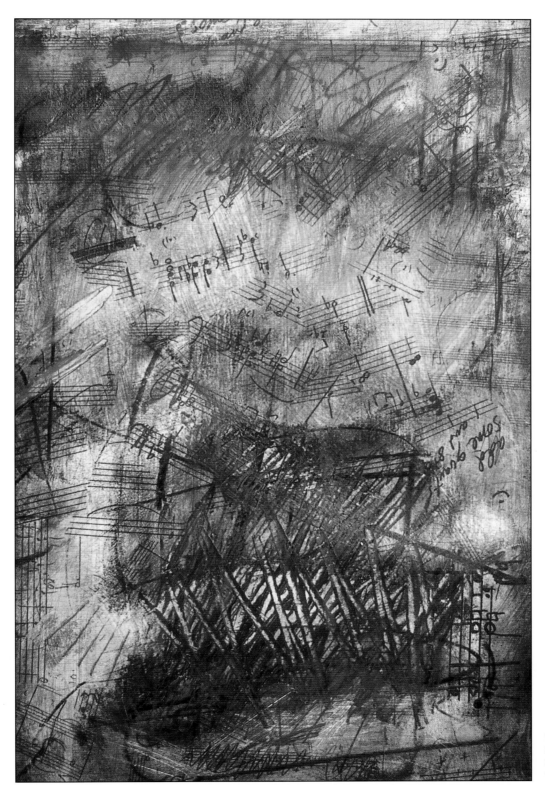

**Variations on a Theme by
Glover, no. 21 of series, 1997**
Oil, mixed media on paper
14" x 8 1/2"

The Studio Book

THE CONVERSATION

Continues

AT TIMES, AN ARTIST NEEDS TO BATTLE IT OUT with her artwork, must listen as those inner voices confront each other. Gradually, however, those conversations become a mutual, sometimes downright friendly, encounter. Now we often seem to be on the same track rather than at loggerheads.

[Conversation between right and left hands, right hand begins.]

12/10/91

I want to be accomplished, able, adequate, monied, respected, in control.
BUT I WANT TO BE REAL WITH PEOPLE AND LET THEM BE REAL WITH ME. I'M NOW SORT OF AFRAID OF BEING MOVED OR VULNERABLE. (sigh!)
And you keep color (expansion and feeling) out of your work. Did you notice how you said today the drawings only speak when you add color?
WELL, I AM WOMAN BUT I AM NO LONGER INFERIOR, SUBMISSIVE, PASSIVE, SOFT.
I beg your pardon? In your work you are certainly scared of taking your foot off the brake. When you go for it, this energy is where your strength lies — and you know it!

For Andrea Bocelli, 2000
Oil and mixed media on paper
42" x 53"

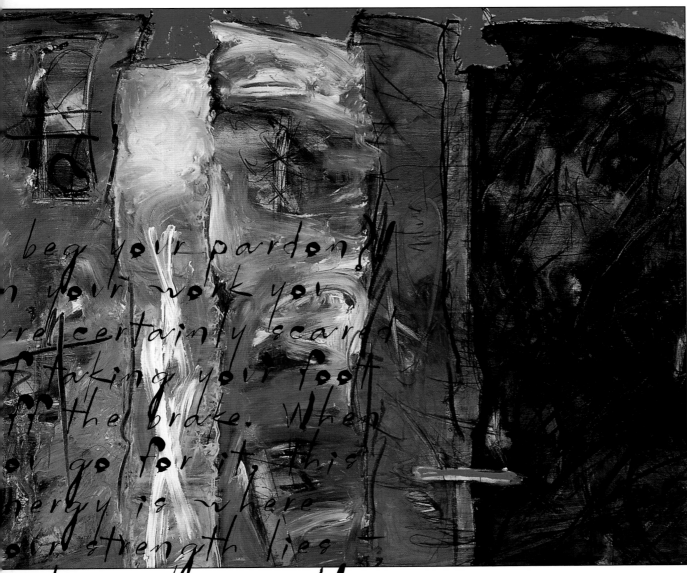

[Conversation between right and left hands, left hand begins.]

12/10/91

I FEEL SOLITARY.

That's okay.

I DON'T WANT TO COMMUNICATE.

My energy level is low, too, and at sixty-four years of age I'm not sure how much I can or want to put into this career from now on...

...I FEAR...

What was that?!

I FEAR I WILL LET YOU DOWN. YOU ARE NOT ABOUT THE HEART, AND I SEEM TO HAVE STORED MINE.

Phew. We need more evenings, more reading, more fires, more music. I need to take care of you.

YES, YOU DO. I AM MORE DIMINISHED THAN YOU REALIZE.

That's why I'm wondering about "retiring" from teaching a year from this January.

BUT THAT PUTS IT ALL ON ME TO BE ABLE TO PRODUCE, AND EVERYONE BUT ME THINKS I CAN.

Why are you such a wimp? You act as if I were asking you to get out of bed. You're not sick — you're just sucking your thumb.

ACTUALLY, YOU SET ME UP FOR THIS. WORKING IN THIS JOURNAL IS A GOOD THING TO DO, BUT IT IS HARD, AND YOU WILL HAVE TO DISCIPLINE YOUR EGO DEMANDS AND YOUR SHOW-OFF WAYS.

Yeah. I want big, fat, energetic, reassuring, solid results, or at least building blocks....It's a nice day. I'll stop, go home, go for a walk, and talk this over with Ken.

4/21/93

This journal is gradually reflecting a lot more who the artist is — not just what the head says and the eye sees, but what the *hand* picks up, moving across the page with a pen.

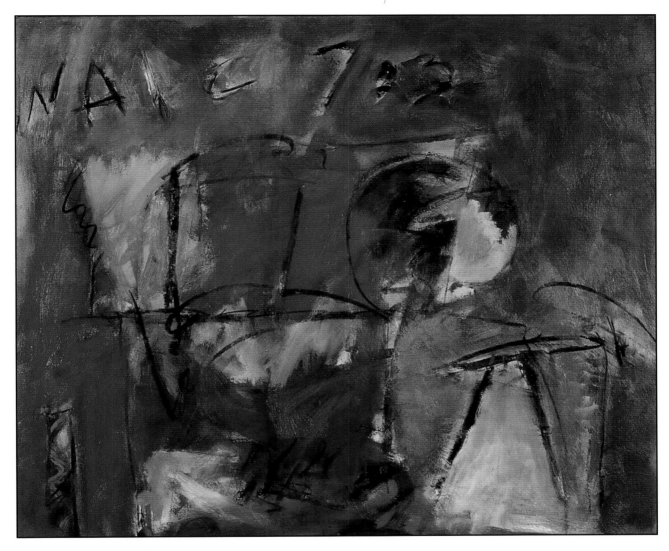

Left on Red, 1994
Oil and charcoal
on paper
36" x 42"

[Conversation with "Left on Red", the artist leads off.]

11/30/93

You are a painting more than a drawing. Back in July, you wanted jazz and an intense blue. Now, listening to Roberta, you go wistful. How do you feel about…
BOY, LADY! DO YOU HAVE TO GO ON AND ON? I'M OK. DON'T MIND HANGING OUT…[SINGS], "IT'S BEEN A LONG, LONG TIME FROM JULY TO NOVEMBER"…
…Okay, okay!…at least you're out of storage, for Pete's Sake!

IT'S BEEN A LONG WHILE, LADY, SINCE YOU JUST DID IT, A LONG WHILE SINCE YOU WANDERED AROUND, FAIRLY LOST, WITHOUT CLUTCHING YOUR COMPOSITION.
You're right. The good stuff that is happening came because I went for failure! Assigned myself several a day —
AND DAMNED IF WE DIDN'T COME UP ROSES. I DON'T MIND BEING YOUR "FAILURE."

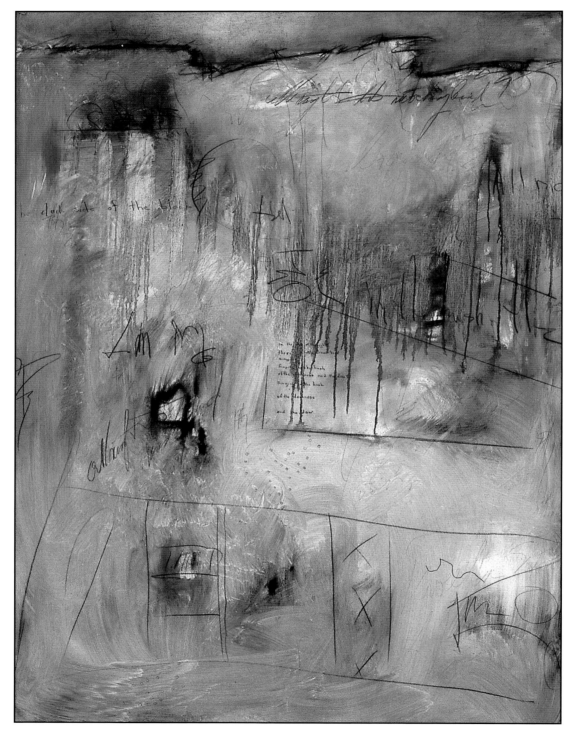

Menlo Park, 1998
Oil and mixed media
on paper
56" x 42"

WHEN PEOPLE SAY, "You must miss California," the high, tawny, short-grass hills, common to so much of the West, appear in my mind. Whether covered with redwoods or barren, the Coastal Range is now the high horizon which haunts the studio and climbs into my compositions.

[Conversation with "Menlo Park," the artist leads off.]

2/2/98

Hi. You are already lovely — like your sister. Just more active.

YEAH. GLAD YOU MADE UP REASONS THAT LET MY SEA/ SKY STAY.

Hmpf. Not sure I care for "made up." Just because my reasons are intellectual, doesn't mean they're not real and valued.

HAVE IT YOUR WAY. S'OK.

Well…What if we doused that sea/sky (resistance — I have a formula. It's working, and now is not the time to leave it).

I AM TWO VOICES. I REALLY ENJOY THE BOTTOM PART.

Yes, sigh. Well. We can turn loose and — Oh. Turn upside down!

FINE BY ME … BUT I THOUGHT YOU SAID, "NOW IS NOT THE TIME TO CHANGE THE FORMULA."

Oh, shut up …come here and let me hug you.

9/26/94

With Gorky you have a sense of place, of a certain space — whether inner or outer. Objects are placed so that they relate to each other. We sense that exchanges are going on between them, with color and value of subtle importance — moving the eye without telling it where to go. I like that sense of place in Gorky. Out West a fence post or a string of barbed wire are evidence that man has passed by — perhaps years ago. In my paintings, broken lines serve that purpose: they leave tracks — little thoughts snagged in passing.

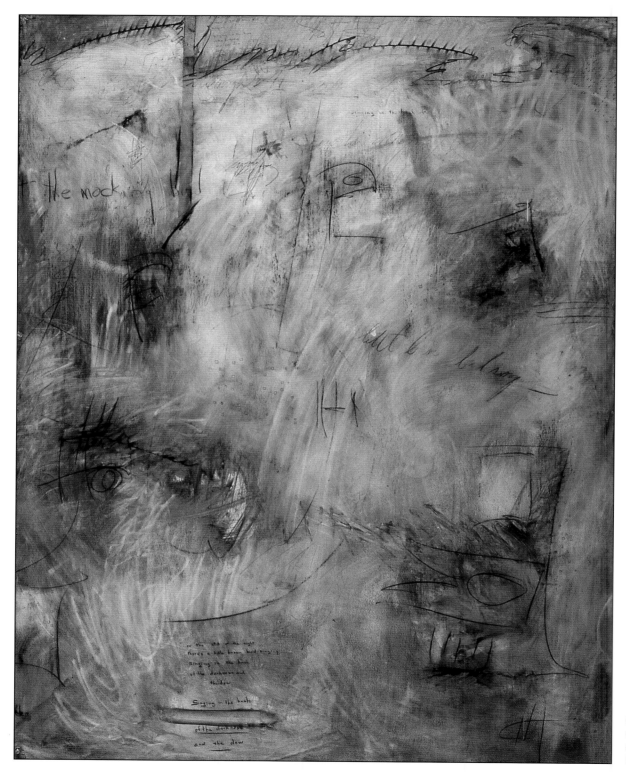

Olive Street, 1998
Oil and mixed media
on paper
56" x 42"

4/22/94

ROOM. Space. Distance. Air. Breathing-room. Space.

Those elements I want in my work because I savour them in my life.

4/16/93

It's good to create space. SPACE is what our visit to Dog Island in Florida's gulf waters was all about. Space and the ever-breathing ocean — so like a person in all its moods. When the ocean storms, scouring the beach, flooding and flushing the salt marshes, we don't see it as bad, but as part of a healthy whole. A person, storming, can be a great relief — or merely vicious violence. My friend Marion kept saying, "Will you do a 'Dog Island' painting?" I resist the suggestion: Dog Island was for the person. A person who paints, an artist who shoves materials around. To that extent, Dog Island will always be in my work.

The Studio Book

Moving On

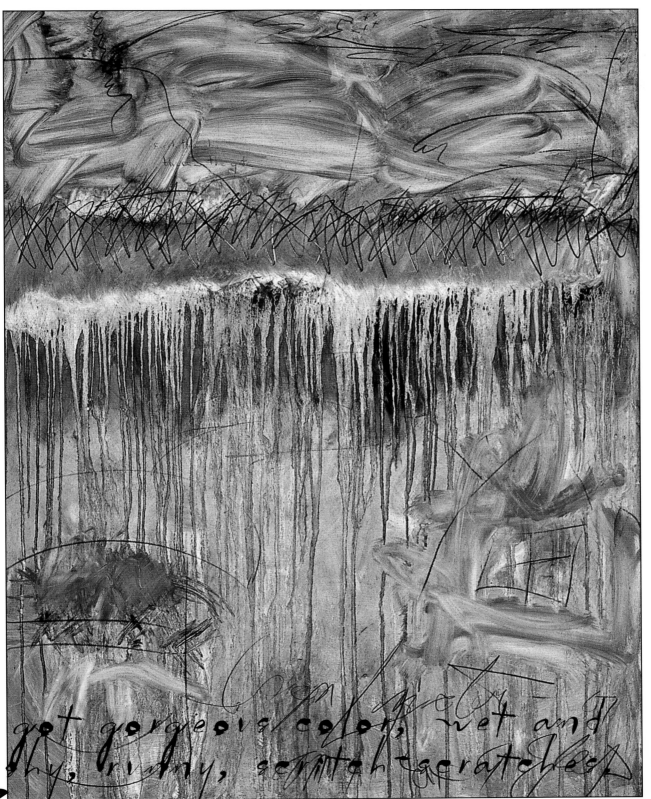

It's got gorgeous color, wet and swishy, runny, scritch-scratches. A Zinger.

[Journal entry tied to "House A'Fire"]

2/1/99
Oh my goodness.
Well. At least it is
a zinger.
Moral. Is this
painting about a
moral?
Keep moving fast.
Use big, "gross"
tools — towels,
sponges.
Don't look — just
swipe around and,
eventually, back off.
This way of
working prevents
one from "saving"
those really nice
parts and makes use
of the large format.
It's got gorgeous
color, wet and
swishy, runny,
scritch-scratches.
A Zinger.

House A'Fire, 1999
Oil and mixed media
on paper
56" x 42"

4/1/92

Hmmm. Thinking of "children in your belly" and the fact that, as a woman, I've spent over two years walking around with a presence inside, one decidedly alive (sometimes kicking!), and yet of which I was, for the most part, unconscious. As such, it shouldn't seem so mystifying (and a cause for griping and indignation) that my unconscious self is cooking up something that won't come "through the neck."

[Conversation with a small gouache. The artist leads off, the painting interrupts.]

Nolde's Carafe, 1991
Gouache on paper
11 3/4" x 9"

And just who may you be –
Nolde's carafe?
Showing in the belly
The urgent voices …

"The neck is too small;
I cannot let them out.
They remain alive,
In conversation staining
My waters with what passes
For wisdom"

[Conversation with a small oil pastel drawing. The artist leads off, the drawing breaks in.]

Black Sister, 1991
Oil pastel on paper
11 3/4" x 9

No words for you,
Black sister —
Children in your belly …

"Kids don't come through your neck,
For God's sake!
But in the warm, empty place
Where the ocean cradles their ears.
And in their own time,
In their own sweet time.
Don't hurry a Black woman,
Sister!"

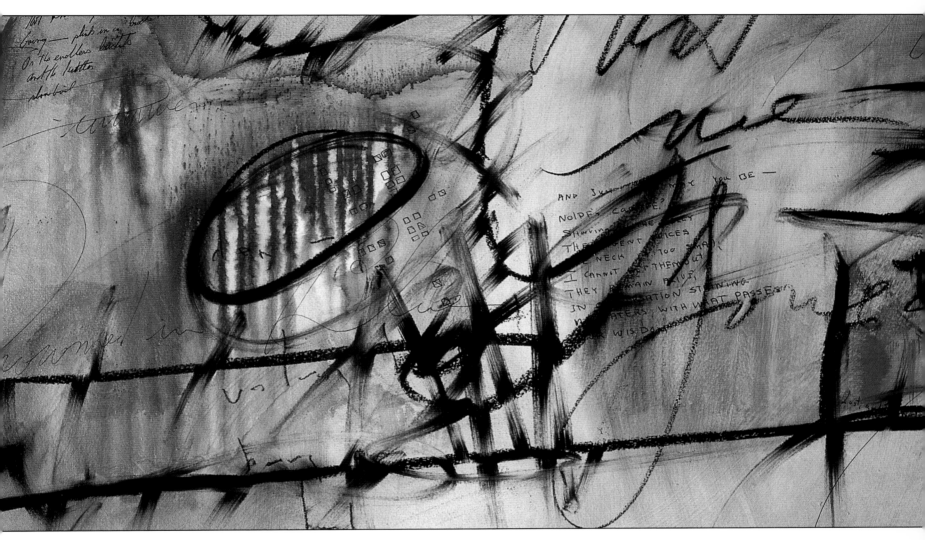

5/94

This one felt like me. Someone said, "You are comfortable with it." Yes, but identity is more than comfort.

Don't Hurry a Black Woman, Sister, (detail), 1996
Oil and mixed media on paper
42" x 72"

5/15/93

Pushing pretty over the brink
into failure was what allowed
beauty to emerge.

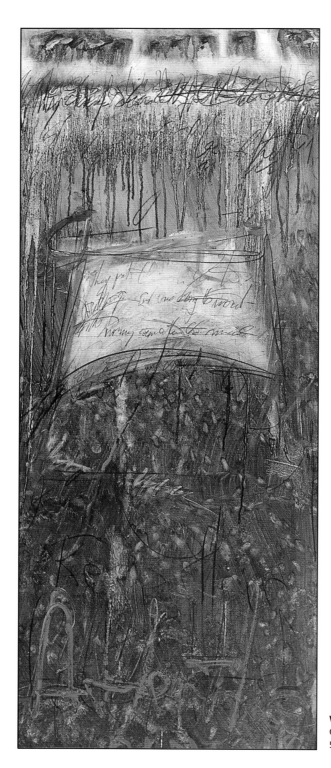

When Beauty Comes, 1998
Oil and mixed media on paper
53" x 21"

7/1/93

I am grateful.

This time began by knowing and saying that out loud

at all times of day, over and over and over.

"What did you do this morning?"

I became grateful.

12/20/97

Hide this one! I've got
to continue building
that convincing body
of work
needed for a major
exhibition.
What's the lesson here?
USE ERASER.
Dare to keep the
"inappropriate."
Dare to lose the nice
parts that make it a
nice painting.
Run your hand over it
as you would a horse
— it shows.

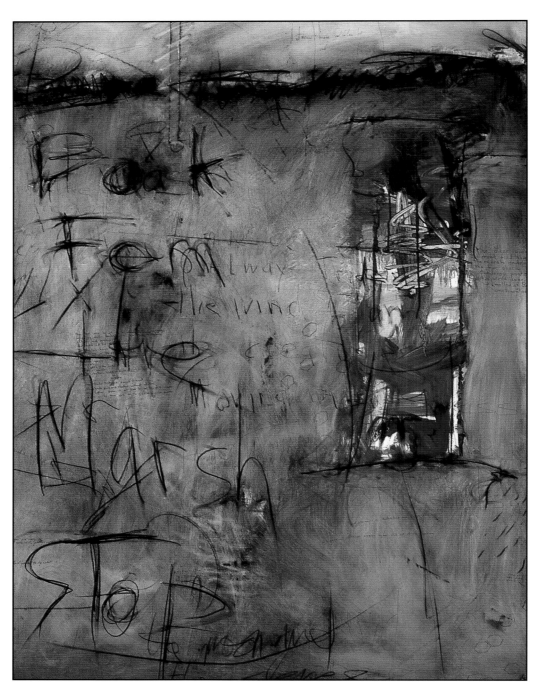

It Took Guts, 1998
Oil and mixed media
on paper
56" x 42"

When I think of future paintings, in my mind's eye I see a basin in the high Western mountains. The paintings are out there somewhere, are horses running free. I walk over to the fence rail, lean on it, and wait. I can hear their hooves, catch sight of their galloping bodies in the low-lying mist. One separates himself, comes trotting straight for the fence and leans on the opposite side. I rub his nose in quick recognition. The flesh quivers, his eye fixes mine — then he wheels and is gone. I want a painting to live as he is alive.

WHEN WE WERE ALL NEW TO THE FARIS BUILDING in the early '80s, David Powers from the upstart young architectural firm across the hall poked his head in the door. He was looking for a Phillips screwdriver. I pointed him toward the toolbox. He found the size he needed and, waving it under my nose, remarked, "This isn't an office building — it's a neighborhood."

That's what we will miss, now that the building has been sold. Oh, the high ceilings, the great open spaces, the walls of windows, the view extending over the city for miles — set those aside. We will miss most Jack Ehle who got us out of assorted fixes, and Bob Faris, who found us artists entertaining and for whom the distrust of one's landlord, generic to artists, mellowed into gratitude and mutual affection. We will miss most …the neighborhood.

4/24/99

Am so grateful to have had the time to let this studio go — to let it go well. (Here Phil Campbell, with his little son Jack — and Glen Fuller — come in, and we all PLOP down and chat while Jack feeds us grapes. Lovely.) I wrap the redwood burl table from those California days in our daughter Beth's old, 1960s India bedspread. Strap it down well to the bottom shelf of my painting table, where it will roll along with the lives and dreams of so many who have worked here.

"Everything is everything," sang Donny Hathaway. There was a time when I didn't understand.

Coltrane's Ballads

Cloudless blue sky

All is light and clearing in this most beautiful of rooms "so easy to remember and so hard to forget."

IS A STUDIO NECESSARY? **Absolutely. This book is a tribute to having a space of one's own.**

A few years back, I was in a shop in Maine, buying a bedspread. The shop's owner, Ruth Vibert — herself an artist — had to climb a ladder to reach the one I had my eye on. Her back was toward me as, reaching for the bedspread, she said, "You must miss the studio. You're never as much yourself anyplace else, are you?" I stood stunned. How did she know?

So, yes, a studio is essential. But wait. In Maine my studio is only a corner of our bedroom, and (if this writing thing doesn't stop pestering me) the time may come when the studio will be that old arm chair and a legal pad — behind a door that closes.

I was lucky to have that great, sunlit studio space with the city spread out beyond the windows. Now the old G. C. Murphy dime store and Granada Theater buildings in Fountain Square provide studio space for many of us in this neighborly part of town. Gradually your studio becomes less a room and more a space within the artist. That is what this book is all about.

Change benefits artists. It shakes us loose, humbles us, makes us start a new journey. Already this scrap is pinned to a wall in the new studio:

2/12/99
One draws a line, a stopping place, at several stages in a painting.
I keep drawing 'til it has a feel, a swing, a composition. Then, breaking out the color, move lightly all around — fencing, touching, spreading. Keeping it open. Take that to a sufficiency where it still jangles lightly as it goes.
Those two states I understand. But when painting begins in earnest, it's as though I'd set the stage. The curtain goes up — and I know neither the script nor the characters.

In river running, we call it "the put in."

Lois Main Templeton

"*A studio is a place for finding one's own voice, an identity uniquely one's own.*"

Acknowledgments

NANCY N. BAXTER OF GUILD PRESS OF INDIANA understood from the beginning what *The Studio Book* was all about. Her enthusiasm confirmed my hopes, her editorial advice clarified many passages, and her Midwestern generosity of spirit welcomed the participation of others in our project.

Joyce Sommers of the Indianapolis Art Center is at the heart of that remarkable center for creative expression. I am grateful to be one of many whose lives are enriched by the Center and by her great good company. That this book benefits and will belong to the Center, is a source of great pleasure.

Several years ago, Lloyd Brooks of Thrive[3] walked into my studio, took a look at the journals lying about, and said, "When you write a book, let me know. I will help you." That he was still willing to do so is my good fortune. Once Nancy and I had polished the text, we knew we could turn it over to Lloyd, saying, "It is yours now," and be confident he would make this book a visual delight — as indeed he has done.

Many friends combed through these pages while *The Studio Book* took shape. Their comments opened my eyes. Again and again, the book came apart and was reformed by our conversations, and at times their wisdom will be mistaken for my own. I am deeply grateful to each one for this companionship.

My family is the reason for this book. What are you going to do with a shelf full of journals?! To spare them the impossible task of unscrambling those pages (and the guilt involved in tossing the lot), I felt the least I could do was to produce one useful book. I hope I have. It is an answer to, "What's for supper?"

Index of Artwork

My thanks to Garry Chilluffo, David Kadlec, and Terry Steadham for their photography.

Suggested Reading

Barber, Noel. *Conversations with Painters.*
London: Collins, 1964

Bayles, David and Ted Orland. *Art and Fear.*
Santa Barbara: Capra Press, 1993

Briggs, John. *Fire in the Crucible.*
Los Angeles: Jeremy P. Tarcher, Inc., 1990

Booth, Eric. *The Everyday World of Art.*
Naperville, IL: Soucebooks, Inc., 1999

Brown, Clint. *Artist to Artist.*
Corvallis, OR: Jackson Creek Press, 1998

Capaccione, Lucia. *The Power of Your Other Hand.*
North Hollywood: Newcastle Publishing Co., Inc., 1988

Cary, Joyce. *The Horse's Mouth.*
New York: Harper Perennial, 1990

Cassou, Michell and Stewart Cubley. *Life, Paint and Passion.*
New York: Jeremy P. Tarcher/Putnam, 1995

Flack, Audrey. *Art and Soul.*
New York: Penguin Books USA, Inc., 1986

Goldberg, Natalie. *Writing Down the Bones.*
Boston: Shambhala Publications, Inc., 1986

Henri, Robert. *The Art Spirit.*
Philadelphia: Lippincott, 1960

John-Steiner, Vera. *Notebooks of the Mind.*
New York: Harper & Row Publishers, 1987

Jones, Max. *Talking Jazz.*
New York: W. W. Norton & Company, 1988

Klee, Paul. *The Diaries of Paul Klee, 1898–1918.*
Berkeley: University of California Press, 1964

London, Peter. *No More Secondhand Art.*
Boston: Shambhala, 1989

May, Rollo. *The Courage to Create.*
New York: W. W. Norton & Company, 1975

McNiff, Shaun. *Trust the Process.*
Boston: Shambhala Publications, Inc., 1998

Ortega y Gasset, Jose. *The Dehumanization of Art.*
Princeton: Princeton University Press, 1968

Potok, Chaim. *My Name is Asher Lev.*
New York: Knopf, 1972

Richards, M. C. *Centering.*
Middletown, CT: Wesleyan University Press, 1962

Sarton, May. *The House by the Sea.*
New York: W. W. Norton, Inc., 1977

Sarton, May. *Journal of a Solitude.*
New York: W. W. Norton, Inc., 1973

Shahn, Ben. *The Shape of Content.*
Cambridge, MA: Harvard University Press, 1957

Truit, Anne. *Daybook.*
New York: Viking Penguin, Inc., 1986

LOIS MAIN TEMPLETON was born in 1928 and came home in a laundry basket during a blizzard. "It accounts for a lot," says the artist.

The family on both sides had left New England and Upstate New York to move west in the 1850s. That their love of the land has been passed on to succeeding generations is evident in *Finding Your Way: The Studio Book.*

In 1947 the author married Kenneth Templeton, whose roots also go back in Wisconsin history. They have three children — Kenneth, John, and Elizabeth — and seven grandchildren. The Templetons lived in the San Francisco Bay area for many years, and they often return to an old shingled cottage in Maine, both influences found in her work.

Lois studied at Williams College and the University of Wisconsin, then turned her attention to family, church and community interests. In 1973, however, she wanted to explore new fields, and enrolled in Cañada Junior College on the San Francisco Peninsula. Their challenging Fine Arts Department was staffed by San Francisco artists of standing. "I was sure I had no talent, but I longed to get my hands on the materials — and to avoid words[!]. Besides, the art building smelled good."

In 1979 the Templetons moved to Indianapolis where Lois continued her studies at Herron School of Art. She graduated magna cum laude in 1981 at age fifty-one. Shortly before graduation, Lois found an old warehouse with spaces perfect for studios in downtown Indianapolis. Within a matter of months, other artists moved in, and "The Faris Building" was born. Over the next eighteen years, this building would become a vital center for visual artists in the city. The journals written during those years form the core of *The Studio Book.*

Lois has taught at several levels — from college to elementary. She finds particular satisfaction in her work as a Master Artist with VSA Arts of Indiana, a worldwide organization which provides educational opportunities and arts experiences for children and adults with disabilities. Through VSA, Templeton has worked with people in correctional facilities and daycare centers, as well as in classrooms across the state.

Templeton's paintings have been given one-person shows in galleries, university venues, and museums on both coasts, as well as in the Midwest. Her work is in the permanent collections of The Richmond Art Museum, The Indiana State Museum, and The Midwest Museum of American Art. It has twice been exhibited at the National Museum of Women in the Arts in Washington, DC. The artist is represented in Indiana by Editions Limited Gallery, by Galerie Hertz in Kentucky, and by The Glass Garage Fine Art Gallery in California. Her studio is in the Murphy Art Center, which is located in the Fountain Square Historic District of Indianapolis.

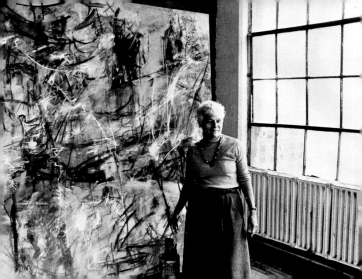

INDIANAPOLIS ART CENTER
LOCATED IN BROAD RIPPLE

Lois Templeton exemplifies our raison d'etre: the Indianapolis Art Center's belief in the creative process as essential to human development. Lois epitomizes excellence of mind in the act of creativity.

The environment of the Art Center encourages creativity through providing studios for making art, beautiful exhibition space to celebrate the product of that art, and an atmosphere that invites dialogue and interaction of a diverse community.

Our mission statement, "to engage, enlighten and enhance our communities through art education, participation and observation," reflects our beliefs.

JOYCE A SOMMERS

President and Executive Director

We wish to thank special friends of the Art Center who have helped make publication of this book possible:

Patron Publishers:
THE CORNELIUS FAMILY FOUNDATION
THE EFROYMSOM FUND AT CICF
SANDY HURT

Patron Editors:
MR. & MRS. ROBERT FARIS, SR.
CLARE HOLLETT
JOHN MALLOM